TERRA INCOGNITA

THE RECENT SCULPTURE OF CHARLES FAHLEN

Terra Incognita
The Recent Sculpture of Charles Fahlen

Exhibition Dates
July 18-September 15, 1991

The publication has been supported by the
National Endowment for the Arts, the Dietrich
Foundation, and the Pennsylvania Council
on the Arts.

The publication *Terra Incognita—The Recent
Sculpture of Charles Fahlen* was prepared on the
occasion of the exhibition organized by the
Institute of Contemporary Art, University of
Pennsylvania, Pennsylvania.

©1991 Institute of Contemporary Art, University
of Pennsylvania, 36th and Sansom Streets,
Philadelphia, Pennsylvania 19104-3289

All rights reserved. No part of this publication
may be reproduced without written permission
from the publishers.

ISBN 0-88454-062-6

Library of Congress catalogue no. 91-72910

Design: Keith Ragone

Editor: Gerald Zeigerman

Typography: AdamsGraphics, Inc.

Printing and color separations: Winchell Press

Photograph Credits:
Greg Benson
Charles Fahlen Sr.
Charles Fahlen
Joan Broderick

INSTITUTE OF CONTEMPORARY ART • PHILADELPHIA

TERRA
INCOGNITA

THE RECENT SCULPTURE OF CHARLES FAHLEN

With an introduction by

PATRICK T. MURPHY

Essays by

STEPHEN WESTFALL AND JOHN B. JACKSON

1 9 9 1

CONTENTS

Introduction

ONUMENT. THE WORD ARISES constantly when considering the work of Charles Fahlen. He uses it in reference to his own pieces, for the forms of his work are extrapolated from natural monuments. Although the term "natural monument" seems oxymoronic, in American argot it has often been applied to the natural landscape, particularly in the descriptions and naming of the American West by early-nineteenth-century explorers.

Here, monument assumes its two main qualities, commemoration and scale. The early expeditions encountered a vast and rich land whose geological features were unknown to them. This was "God's own country," an epic landscape in which form and scale bore no relation to Western man or his civilization. The structures of Monument Valley led some of these adventurers to believe that nature alone could not be responsible, so the landscape itself became the evidence of, or monument to, the existence of a higher order. As the myth of the frontier grew, the bounty and capacity of the territories were synonymous with the biblical land of milk and honey. The Western expanses were the new covenant; the notion of land was linked inextricably to religious belief.

The twentieth century has seen the violation and redetermination of the symbolic dynamism of land in the American psyche. Now, the most impressive areas of wilderness have been parceled and preserved as memorial to a landscape that once was monumental. The national parks system can offer a simulacrum of the discovery experience to any tourist. Within their controlled boundaries, the epic can purport to exist; form and scale remain—but in the custody of rangers.

In this atmosphere, Charles Fahlen spent his formative years. Annual family pilgrimages to Yosemite, Yellowstone, Monument Valley, and other parts of the western states encouraged his abiding interest in nature and the literature of exploration. Later, as a young artist, he confronted the problem of how to make art out of his own experience when the contemporary discourse was limited to or reacting against the stricture of Greenbergian theory. Initially, Smithson pointed the way with his dialectical approach to the exterior

and interior presentation of landscape. Joel Shapiro's austere manipulation of scale also interested him. Using the idiom of minimalism, Fahlen began to make small self-contained objects. The material (industrial) and process (fabrication) are the only components of minimalism that Fahlen utilizes. He rejected the programmatic progression to strict objecthood in favor of a more poetic, metaphorical sculpture.

The forms of his recent sculpture arise from the spectacular geological features of the West. Fahlen extracts the underlying geometry of a particular feature to produce a skeletal notation of its form. Robbed of its mass, Fahlen then decreases its scale to reference the human body. This sculptural alembic echoes the transmutation of the West from a divine land—preexploration—to a monument to divinity—the period of western expansion—to a park for divine monuments. Perhaps the industrial language of minimalism offers the most appropriate means of commentary on this sequence of the mythical reduction of landscape to tourist industry.

Within these diminished monuments, Fahlen carries out a sophisticated formal play with materials. Two, three, sometimes more materials are mixed in the construction of the pieces to produce inventive and idiosyncratic combinations. These juxtapositions serve to strengthen the incongruity of the natural forms he mimics, like the outrageous hoodoos that seem posed in a comical balance, acknowledging gravity while defying it. Added to this playfulness are visual puns based on childhood objects. The punching-bag clown, the cartoon telescope, the spinning top, the collapsible camping cup, all take the previous reduction of scale and turn it on its head into giganticism. This formal slapstick heightens the poignancy of the cultural and personal loss addressed in the pieces. Fahlen's position may be existential, his modernism late, but there is nothing belated about his practice. The pertinence lies in his compelling articulation of the atrophy affecting a major metaphor of this society.

Stephen Westfall cogently places the implications of this body of work within both the nature-culture discourse and the larger arena of nineteenth-century romanticism and

twentieth-century modernism. We are grateful to him for his critical study of Fahlen's work. John B. Jackson has long been writing and conjecturing about the reality and myth of the American landscape. His afterword contextualizes the concerns of the artist and invites us to begin our own speculation on the dynamic and evolution of that myth.

I wish to thank the lenders to this exhibition for parting so generously with the artist's work. Beatrice Fulton, who worked on all aspects of the exhibition, helped considerably in bringing our efforts to fruition. Roy Goodman, of the American Philosophical Society, kindly directed us in our examination of early books on Western exploration. William Rumley assisted the artist in the creation of Colter's Hell; we are appreciative of his cooperation and expertise. This series of exhibitions has been supported by the Dietrich Foundation. We are grateful for its continued encouragement. We also wish to thank the Pennsylvania Council on the Arts, the National Endowment for the Arts, and the Institute of Museum Services for their support of ICA and its programs.

Charles Fahlen is the recipient of our greatest appreciation. His enthusiasm and commitment to this project has been an inspiration to all involved.

Patrick T. Murphy

RUINS OF LANDSCAPE

STEPHEN WESTFALL

CHARLES FAHLEN IS A SCULPTOR whose art assumes the infusion of referential content into the forms of geometric abstraction. His pursuit of memories and associations beyond the self-referentiality of abstract essences has returned him to our culture of images, shaping a poetic sensibility as thematically complex as it is formally elegant. Metaphor is strongly at work in the calibrated simplicity of his forms, and it is clear that some kind of nature-culture discourse is being proposed. Fragments of forms acquired from culture and inspired by the striking natural features of the landscape of the American West are touchstones for reverie in his imagery. Fahlen's reverie takes him inside and out—to a recovery of his own history through evocations of the history of certain acculturated sites, along with homages to the New World myth of the frontier.

Tales of exploration and travel enthralled Fahlen as a boy, and continue to fascinate him to this day. His family took early trips by car from San Francisco to visit his grandparents in Arizona, and made regular visits to Yosemite National Park where they had a vacation home in a homesteaded square mile in the Wawona section. In Yosemite, Fahlen witnessed the now-discontinued spectacle of the firefall, a bed of red-hot coals that camp rangers pushed off one of the towering granite cliffs at the end of an evening's tales of nature and Indian lore. The landscape of Fahlen's childhood is illuminated by such powerful images and forms. The spilling glow of the firefall is echoed by the splash of a cave lantern across stalactites and stalagmites, the buttes and spires of Monument Valley, and the natural sandstone bridges in Arches National Park.

An awareness of the power and appeal of art had long been present in Fahlen's family. His father's doodlings of imaginary animals in multicolored inks are hilarious; alarmingly detailed hybrids of fish, birds, and insects, many with human expressions, go far beyond idle sketching, recalling the hallucinatory and satirical drawings of James Ensor. Fahlen's grandfather, in Arizona, was quite a respectable painter in a Southwest Barbizon style.

It is curious that when Fahlen himself chose to become an artist, he veered emphatically in the direction of sculpture. Perhaps, in spite of the vivid presence of a familial pictorial tradition, his childhood was even more abundant with powerful apprehensions of sculptural

form. In the distance, there loomed the stark and suggestive forms of natural monuments, not least the myriad hoodoos, the strangely anthropomorphic, stacked rock forms that dot the terrain of the Southwest. Close at hand were the intimate massiveness and visible mechanics of camp furniture, the richness of texture in everyday objects lying about his grandparents' residence, and the loopy statuary mannequins advertising roadside America. These experiences are not unique to Fahlen's boyhood, but he appears to have been extraordinarily open to their sensuous impact.

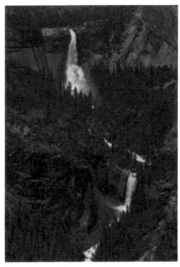

NEVADA VERNAL FALLS, YOSEMITE VALLEY

Another major source of Fahlen's imagery is his avid reading on the history of exploration. Much of his imagery evokes a conception of a frontier or refers directly to the forms of navigational and astronomical instruments. The terms of exploration, of course, have changed dramatically in the last century. The closing of the territorial frontier barely preceded the first tentative mappings of the unconscious and the systems of structural anthropology.

Exploration continues to mean "to discover" to a child, for whom a trip by car is a voyage of discovery. To an adult, however, exploration more often means "to uncover." The physical frontier has been replaced by multiple frontiers of textual and psychological dimensions. We step into a new place and are aware that it is new only to us. We are cognizant of the cultures that precede us and the culture we carry. Fahlen's indoor and outdoor work traverses the pursuit and recovery of personal and social history, and it does so through the forms of a textually enriched abstraction.

Fahlen's art divides into indoor and outdoor sculpture and more architecturally dispersed site-oriented work that uncovers and responds to the history of place. A new, large-scale indoor piece, *Colter's Hell*, combines elements of both. A look at the closed single-form pieces, which represent his core practice, indicates that his abstraction extrapolates from both the natural world and

from culture. Sometimes his forms are de- and recontextualized fragments of his source image; on other occasions, they are projections into geometric simplification and abstraction. Quite often, these routes to a finished sculpture will overlap since they are not antithetical to each other. Fahlen's work shares with Bryan Hunt, Phoebe Adams, R. M. Fischer, Robert Lobe, and Judith Shea, among others, a sculptural relation to New Image painting.

New Image painting isolated and emblematized fragments of recognizable subjects, presenting them with a geometric clarity that heightened the apprehension of the shape-value of the surrounding "negative" space. New Image sculpture, for want of a better term, enacts a similar sequence of perceptions in real space. Fahlen's sculpture usually cuts a sharply articulated silhouette in space as it works back to geometric form from its empathic source. *Pearly Gate* (Plate 3) and *Betatakin* (Plate 1), although inspired by the stalactites and stalagmites of underground caves, have "evolved" to the pure geometries of the cone, cylinder, and pyramid fabricated out of industrial materials, namely various types of treated steel. Part of the process of each piece is Fahlen's negotiation of the tran-

sition from comparatively unruly natural form to the crystalline realm of geometric classification and cultural production.

It is difficult to determine why this movement from source to abstraction should feel so poignant in Fahlen's work. A certain poignancy is a prevailing mood among New Imagists, who impose abstraction on representational imagery through isolation and lay siege to our confidence in scale. One is aware in this work of a hypersensitivity to the consequences of aesthetic classification, the analytical denaturalization of experience away from its incantatory, sensorial primacy. The corollary, in regard to scale, is felt when the monumental sublime is collapsed to human scale. Human scale, in turn, is further diminished or rendered comic. One way to read Fahlen's indoor sculpture is as theatrical devises or props; it is hard to resist the impulse to try on one of his cones as a dunce cap or, noting the alchemy of aesthetic transformation, as a wizard's hat.

Fahlen's abstraction urbanizes the primal natural forms of his past, making us aware that this act of retrieval is not accomplished without a sense of loss. The power of such form may have best been described by

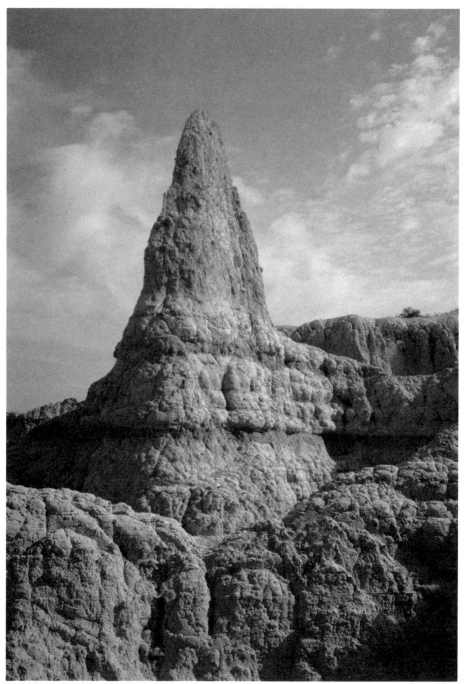

BADLANDS, SOUTH DAKOTA

Wordsworth. In the first book of *The Prelude*, he reminisces about a boyhood theft of a small boat for an evening's joyride on a mountain lake. He turns back in fear, though, when the mountains, and one pinnacle in particular,

> Towered up between me and the stars,
> and still,
> For so it seemed, with purpose of its own
> And measured motion like a living thing,
> Strode after me. . . .

He returns the boat to its mooring,

> And there through the meadows home-
> ward went, in grave
> And serious mood; but after I had seen
> That spectacle, for many days, my brain
> Worked with a dim and undetermined
> sense
> Of unknown modes of being; o'er my
> thoughts
> There hung a darkness, call it solitude
> Or blank desertion. No familiar shapes
> Remained, no pleasant images of trees,
> Of sea or sky, no colours of green fields;
> But huge and mighty forms, that do not live
> Like living men, moved slowly through
> the mind
> By day, and were a trouble to my dreams.

To bring such forms indoors, to domesticate and abstract them, is the necessary beginning of liberation from certain fears and the inauguration of a new and more complex level of play.

Fahlen's *Half Dome* (Plate 6) comically miniaturizes and schematicizes the most famous of Yosemite's mighty cliffs. On the face of the gridded scaffolding that holds the shape of the Half Dome, Fahlen has fixed small hunks of granite like notes on a musical staff. Half Dome is a monolith, one of the largest in the world. Fahlen has rendered its silhouette and contradicted its mass with an open framework that segments and frames volumes of air. Granite chunks, which are posted on the coordinates of the grid, "represent" granite and configure an image of precariousness. The piece diagrams its empathic source, a mountain presence grand and brooding enough to trouble the dreams of such Wordsworthian visionaries as Muir and Bierstadt, and, by diagramming, enacts the transition from the world of appearances to the diagrammatic model in Western art that begins with cubism.

> The metaphorical model of cubism is the *diagram:* the diagram being visible, symbolic representation of invisible processes, forces, structures, a diagram eschews certain aspects of appearances: but these too will be treated symbolically as *sign,* not as imitation or re-creation.[1]

If the closed skin and massive solidity of the actual Half Dome is perforated by volumes of air in Fahlen's sculpture, that is part of the aesthetic pleasure of the diagrammatic image that explodes linear constructs so that information may pass around and through the open spaces.

The diagram becomes the paradigmatic image of the sign—that praxis where distinct trajectories of information and interpretation intersect, overlap, and change course. The diagram is hardly the exclusive means of representing sign. "The Empire of Sign" is everywhere; we drift into it.

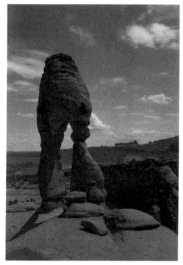

ARCHES NATIONAL PARK

> The pleasure of the text is not necessarily of a triumphant, heroic, muscular type. No need to throw out one's chest. My pleasure can very well take the form of a drift. Drifting occurs whenever I do not respect the whole, and whenever, by dint of seeming driven about my language's illusions, seductions, and intimidations, like a cork on the waves, I remain motionless, pivoting on the intractable bliss that binds me to the text (to the world).[2]

Any form may enter this domain, set in motion, perhaps, by the gentle push of a title. *Kayenta* (Plate 2) is the title of a Fahlen sculpture; it refers to a trading-post junction east of the Grand Canyon and south of Monument Valley. There is a low-slung, rustic desert lodge in Kayenta where George Herriman, the creator of Krazy Kat, spent time. There's an unmistakable cartoon jauntiness to the stacked telescope form of Fahlen's sculpture, and one recalls that Krazy Kat characters are forever spying on one another with telescopes; indeed, the telescope is one of the standard anticipatory devices of cartoons. The telescope takes the eye to the far horizon (and in the desert that can be a considerable distance), but Fahlen's form is standing upright, lens to the ground. In this configuration, it resembles a cockeyed building or one of the hoodoos that offers feeble concealment and marks distance in Krazy Kat's surreal terrain. Fahlen's sculpture is a point of departure for a leisurely interrelation of scale and

cultural location. The delicate scale of a hand-held navigational instrument is transposed onto the monumental scale of natural rock formations, finding a common ground in the human scale of the actual piece, where the costume or stage-prop association is acutely felt. *Kayenta* allows the mind to move between low culture and high, nature and culture, comic-strip narrative and the lonely forms that haunt the imagination of the American West.

The American imagination has always been driven by, and into, its open spaces. Beyond the vibrant nineteenth-century practice of landscape painting, led by Cole, Moran, and Bierstadt, among others, it is important to note the overwhelming influence of nature and the symbolist spirit of natural forms in the art of the first American abstractionists—Dove, Hartley, Marin, and O'Keefe. Robert Rosenblum established a compelling link between abstract expressionism and the northern European romantic tradition of landscape painting exemplified by Casper David Friedrich, and it seems plausible that the sense of scale and open space in the abstract paintings of Pollock, Still, Rothko, and Newman could have occurred only in post-World War II America, where hope was still reified as boundless space. A dialectically cooler and more industrially merged vision of extension propelled the endlessly repeatable forms of minimalism.

New Image painting and sculpture does not shut down extension but shifts the frontier from the physical plane to the textual, while retaining romantic vestiges of presence. It is not an art driven to an end, even if a sense of limitations is one of its formal and thematic tropes. Instead of an art of comic diminishment and melancholy detachment, it is now apprehensible as an art of drift, of reverie. In *The Psychoanalysis of Fire,* Gaston Bachelard contrasts reverie with dreams:

> This reverie is more or less centered upon one object. The dream proceeds on its way in linear fashion, forgetting its original path as it hastens along. The reverie works in a star pattern. It returns to its center to shoot out new beams.[3]

The object provoking the reverie may also be a subject, an idea. New Image painters may induce the reverie that leads them to an object through a free-floating contemplation of the nature of figure-ground relationships. One of the aims of art—itself a product in large part of reverie—is to induce reverie.

Fahlen's *Dirty Devil* (Plate 4) takes its concentric form from a collapsible drinking cup, the kind one takes along when traveling or camping. The sculpture is named for one of the last tributary rivers to run into the Colorado River as it makes its way through the Grand Canyon. The interior of the sculpture—a cutaway view of a segmented shell sloping upward and outward like a canyon wall—is a recognizable exaggeration of the shape of a dam. A cup becomes canyon wall and gigantic dam; in the actual presence of the sculpture, all associations are joined in the evoked scale of the human figure. As on Bachelard's description of reverie, *Dirty Devil* dispatches our thoughts in radial directions so that they may return ultimately to deposit fresh layers of interpretation.

The image of the dam in *Dirty Devil* raises particularly intriguing issues of the psychosocial content of the American landscape. Dams have fueled population growth and recreational development in the West; in doing so, they have flooded some of the most spectacular wilderness in the country. The air pollution from the power station at Lake Powell and the buildup of silt in the Colorado River threaten the ecological stability of the entire Grand Canyon. The damming of the Hetch Hetchy River, in California, erased a valley held by John Muir to be as beautiful as Yosemite. The dam becomes a metaphor for the erosion of nature by man. Yosemite itself has become an overcrowded amusement park on the valley floor. A backpacker cannot cast eyes across the wildest stretch of territory without seeing a power line or a jet trail.

One of the unmistakable messages of Fahlen's sculpture is that the primal, boundless territory of nature—an imaginative cultural construct of nineteenth century romanticism or a powerfully shaping experience from our own childhood—is at a close.

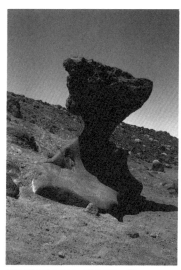

FORMATION, DEATH VALLEY

And it is appropriate that the drama of its passing should be enacted in the Tombstone Territory of the American West, which held the last great promise for a settleable territorial frontier to the Western mind. We know that at various times in history the European imagination was inspired to reverie by the contemplation of its medieval and classical ruins. The only really comparable ruins in America are the cliff dwellings in the Southwest (the sculpture *Betatakin* is named for one of them). The American landscape itself is a ruin, both in physical fact and the metaphoric power of its shadowed, crumbling grandeur.

The most recent installation by Fahlen is a large-scale scatter piece entitled *Colter's Hell,* which serves as a meditation on our memory, ruin, and displacement of the natural landscape. This installation has its thematic genesis in the Lewis and Clark diary Fahlen read over a year ago. He came across references to John Colter's then-unverified discovery, in 1807, of the volcanic and geyser-laced region of what was to become Yellowstone National Park. Colter was a trapper, guide, and member of the Lewis and Clark expedition, but he couldn't write. Consequently, secondhand accounts of his

own explorations did not reach print until decades later. The region became known derisively, among disbelieving fellow trappers, as Colter's Hell, although the Indians had told Clark about "a place where the earth trembled and frequent noises like thunder were heard, a place where their children could not sleep, a region possessed of spirits averse to the approach of man."[4]

Fahlen's rendering of *Colter's Hell* is not quite so tumultuous, but reverie never really is, even when inspired by tumult. He mixes water and stone by distributing warmly pigmented castings of kitschy items and recreational detritus—everything from gnomic lawn ornaments to cycle helmets—around circular fountains cast in fiberglass. Although a definite scatter aesthetic pervades the work, Fahlen's penchant for geometric organization is immediately apprehensible as a structuring backbone. The circular water basins are arranged in a quadrant so that circles and squares become a dominant feature of the piece. A nongeometric formal element binding together the disparate forms is the color of the concrete castings. The colors are richly tonal; as each seems to contain some of the others within itself, a uniting atmospheric fog envelops them all.

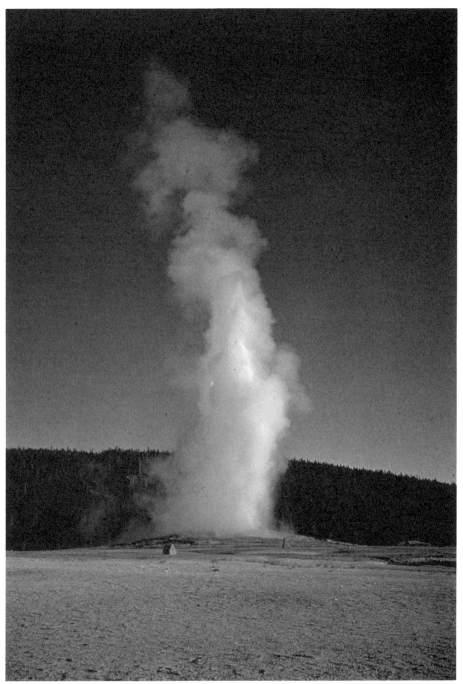

OLD FAITHFUL, YELLOWSTONE NATIONAL PARK

The castings recall both the great fossil fish that Colter reported seeing on his journey and the hoodoos that the Indians believed were also possessed by spirits. There is something vaguely totemic about the castings, but life and intentionality flicker in Fahlen's forms in a different way than they might in a moonlit hoodoo, church gargoyle, or tribal totem. It is possible to find a washed-out, consumer-directed animism in the exaggerated winsomeness of the cartoon expressions worn by some of Fahlen's castings, or a body-active use value implied by those forms sprung from recreational tools.

These implications are categorical ghosts of the incantatory power of presence once invested in the natural and cultural forms they evoke. Fahlen's work is haunted not only by the ruins of landscape but also by the ruins of belief; perhaps they are in some way inextricable from each other. And yet, the ruins about us are always more pertinent, more vital as ruins than the unworkable or abandoned wholes they represent. Through their cultivated fragments, we reawaken to the power of forms to inspire reverie and the power of reverie to regenerate wonder.

Notes

1. John Berger, *The Sense of Sight* (New York: Pantheon, 1985).

2. Roland Barthes, *The Pleasure of the Text*, Richard Miller, translator (New York: Hill and Wang, 1975).

3. Gaston Bachelard, *The Psychoanalysis of Fire*, Alan C. M. Ross, translator (Boston: Beacon Press, 1964).

4. Stallo Vinton, *John Colter, Discoverer of Yellowstone Park* (New York: Edward Eberstadt, 1926).

Stephen Westfall, artist and critic, regularly contributes to Art in America.

PLATES

Plate 1

BETATAKIN, 1987

90 x 24 x 25

Zinc-plated steel and steel

Mr. and Mrs. Daniel W. Dietrich, II

All measurements are in inches; height precedes
width precedes depth.

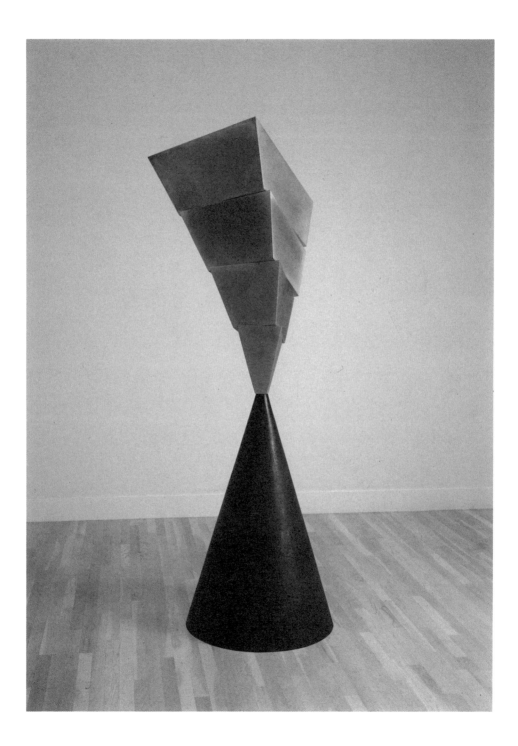

Plate 2

KAYENTA, 1987

90 x 16 (diameter)
Stainless steel, purpleheart wood, bronze, hot
rolled steel
Courtesy Lawrence Oliver Gallery, Philadelphia

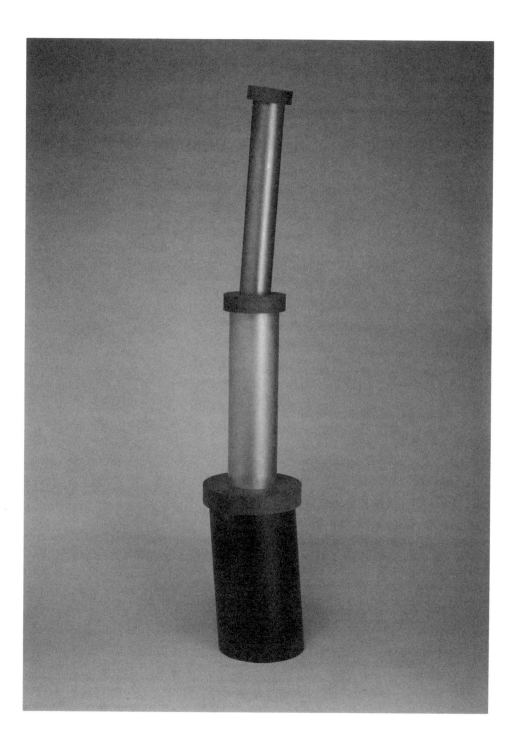

Plate 3

PEARLY GATE, 1987

79 x 23 (diameter)

Stainless steel

Towers, Perrin, Forester, & Crosby

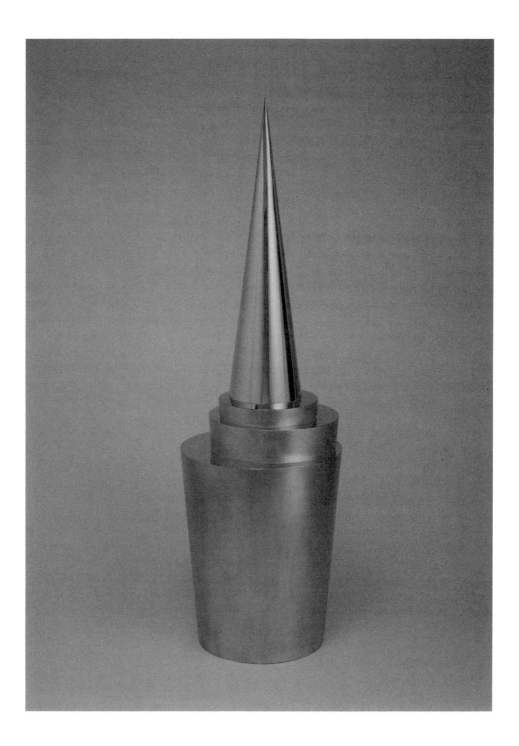

Plate 4

DIRTY DEVIL, 1988

56 x 44 x 46

Aluminum

Courtesy Lawrence Oliver Gallery, Philadelphia

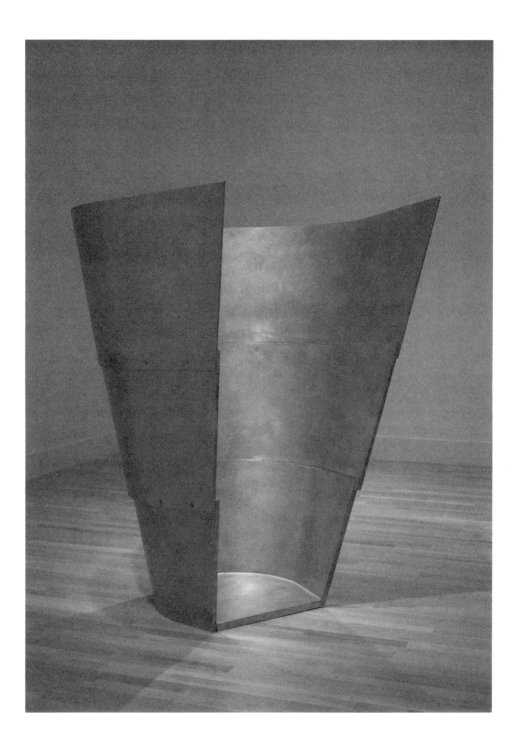

Plate 5

BOZO, 1989

76 x 31 x 31

Lead, stainless steel, brass, and aluminum

Courtesy Lawrence Oliver Gallery, Philadelphia

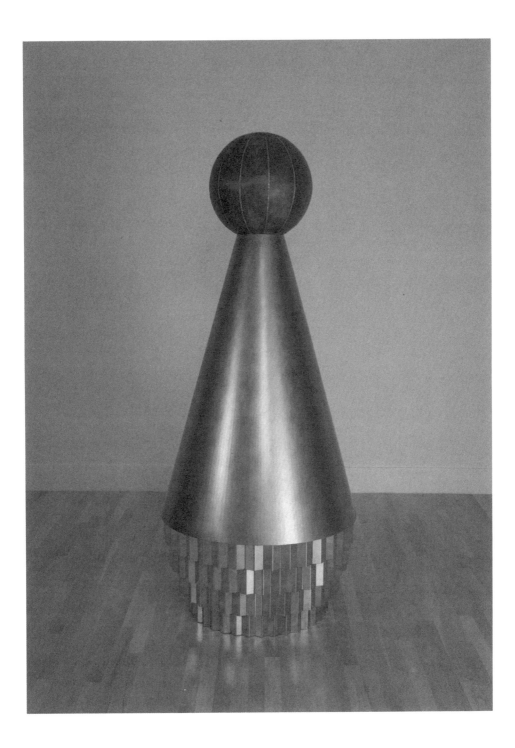

Plate 6

HALF DOME, 1990

99 x 72 x 30

Stainless steel, granite

Courtesy Lawrence Oliver Gallery, Philadelphia

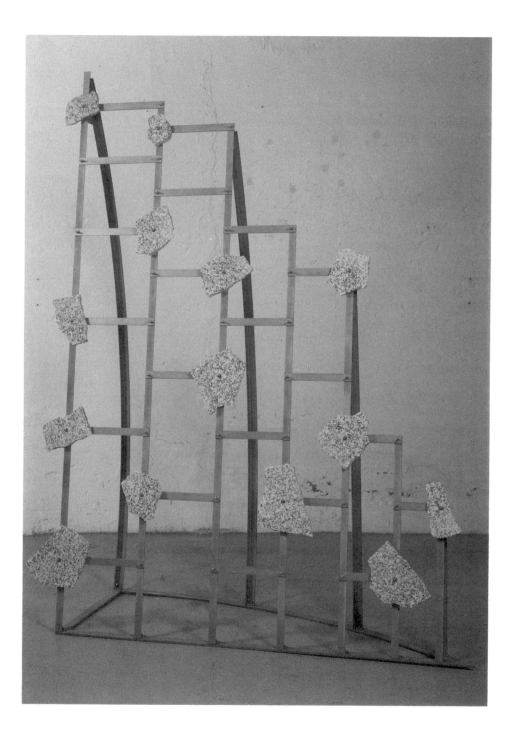

Plate 7

SPIDER WOMAN, 1991

132 x 70 x 25

Bronze, cast stone

Courtesy Lawrence Oliver Gallery, Philadelphia

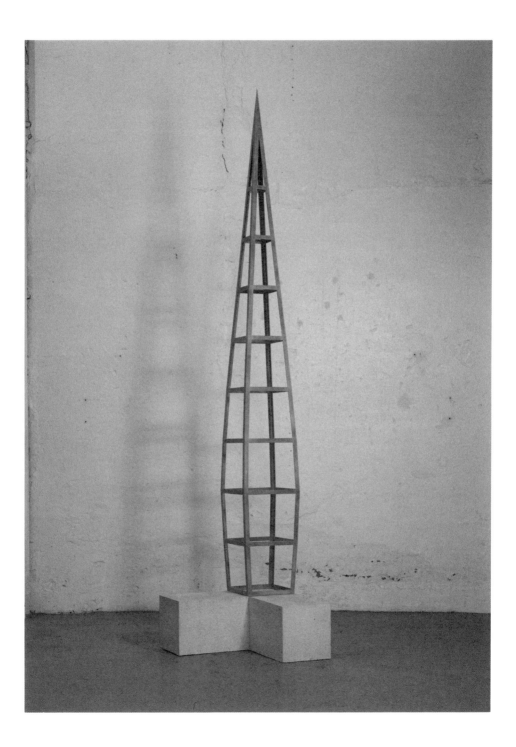

Plate 8

COLTER'S HELL, 1991

66 x 39 x 28

Stainless steel, cast stone

Courtesy Lawrence Oliver Gallery, Philadelphia

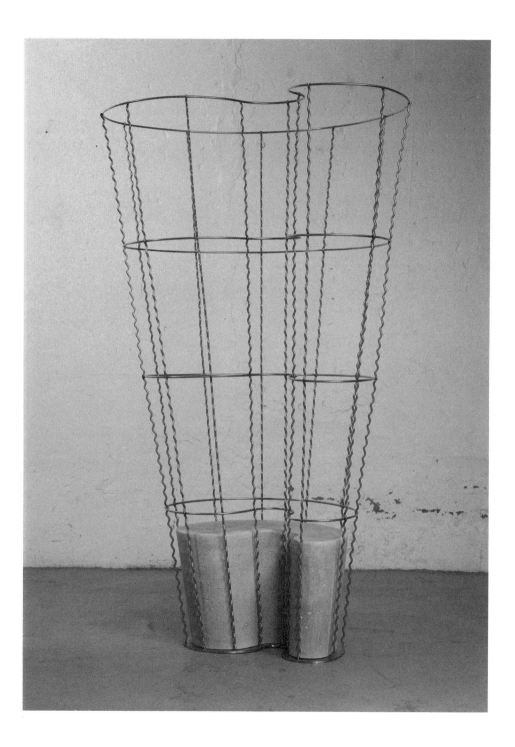

AFTERWORD

JOHN B. JACKSON

IT DID NOT TAKE MANY YEARS FOR AN industrial landscape to evolve in the Eastern states. At the time of the Revolution, we were still a nation of small farms and small towns surrounded by wilderness. A half-century later, we had railroads and canals and factories and a score of new industrial centers. The new landscape did not in the beginning threaten any discordant changes. The new mill village, rows of neat identical cottages and gardens, could have been mistaken for an egalitarian farm community, and the three-story mill, with its belfry and picturesque location on a millstream, resembled a benevolent institution—a college dormitory, perhaps, or an orphanage; nothing to be afraid of. The first railroad journeys were holiday excursions, greeted at every stop by patriotic oratory, and the massive stone bridges and canal locks gave the rural landscape a classical dignity. Lowell, the first new factory town—with its familified style boardinghouses for the women workers, its lectures on phrenology, its literary magazine—seemed to many foreign visitors a utopian creation, well worth copying. The farm landscape continued to flourish. The view of every village was dominated by a church steeple.

In the course of a generation, disillusion set in, but it was then too late. Confinement in the factories was discovered to be unhealthy, and instead of more cottages there were a proliferation of tenements, and then slums. Too many immigrants came in search of jobs; rivers and millponds were polluted; dark smoke poured from the tall factory chimneys. Preachers and journalists lamented the decline of the old household arts and crafts, the prevalence of rubbish, the unseemly contrast between poverty and wealth. Books and essays appeared expressing nostalgia for the old rural order.

Yet, in time, something like an uneasy adjustment between the two landscapes came to pass. The two life-styles still had traits in common: the same architectural heritage, the same dependence on a stable community. Farmers and operatives still shared a work ethic and a tradition of popular manual technology, and even a sense of a social hierarchy. If the industrial city was by general agreement the place to seek prosperity and excitement, what survived of the rural landscape was still the place for holidays and family reunions, for hunting and fishing in the familiar forest, and for communing with nature. It was still the place where old ways

were the best ways, and where the past remained stubbornly present.

After the midcentury, the logical region to look for something like the old, preindustrial landscape was the West beyond the Mississippi, as far as the Pacific coast. It was scantily populated, rich (by all accounts) in natural resources, and beautiful. Those who went there, either as tourists or settlers, soon fell in love with its scenic variety, spaciousness, cloudless skies, and promise. It was true that the West lacked the sense of history of the East—the Spanish and Indian heritage did not count—and that the farms with their hundred-acre fields of corn or wheat, the cattle ranches the size of an Eastern county, made for a landscape intimidating in scale. And there were natural hazards never dreamt of in the older parts of the nation—drought and fierce blizzards and desert. On the other hand, tourists traveling by rail discovered the still-unblemished beauty of the California coast and the magnificence of the Rockies, in Colorado. And best of all, there were no cities, no factories, no crowds. For those who had money and leisure, a series of small, idyllic landscapes came into being: ranches with luxurious headquarters and a body of picturesque and loyal cowboys;

hunting lodges in the mountains; and Mediterranean-style resorts along the coast. Their fortunate inhabitants traveled from place to place by comfortable train. Looking out the window, they glimpsed the cabins of gold miners far off in the wooded mountains, the villages of Indians, and the herds of antelope and buffalo on the treeless plains.

It was the popularity of the automobile, beginning in the twenties, that revealed to many tourists new aspects of the West, and also revealed a new (or hitherto neglected) approach to the landscape. Until then, few travelers, except for hardy explorers or tourists in well-organized excursions, had ventured into the back country or the desert. The current canon of landscape or topographic beauty, established long ago in Europe and carried over to the East, did not recognize the abandoned mining village, the solitary rock formation protruding from the flat rangeland, or the half-obliterated remains of ancient Indian settlements. Based as that canon was on aesthetic and historical awareness, it saw no place for the grass-grown road leading into the hills or the water hole with its dense crowd of cattle. The automobile not only made those obscure places accessible but made them accessible

to a very mixed public: farmers, ranchers, truck drivers, salesmen, would-be settlers, and, of course, tourists. Had they been properly briefed for their journey, they would have known enough to avoid the long, straight, monotonous roads and to seek out the recognized beauty spots; they would have carefully chosen where to spend the night. They would have learned something of the brief history of the West and its economy. But most of them—like most of us—made no plans, little or long range; as a result, they moved from surprise to surprise. They ate their lunch in a grove of cottonwoods next to a river whose name they never knew. They took pictures of strange rock formations, got lost, and wound up in a sawmill company town. A passing cowboy helped them change a tire. They attended a camp meeting by mistake. But, after all, they had a destination to reach. They moved on, and when they arrived, they admitted to themselves that they had seen very little of the *real* West.

But this is how travelers, and even many of us who stay put, now make landscapes. Each of us accumulates a jumble of impressions and eventually sorts them out in a time sequence. In the wide-open West, a distant, pale-blue range of mountains, never coming nearer throughout the day's travel, provides us with all the sense of place we actually need. The landscape takes form through introspection and memory. That is why our vision of the world is so different from that of even the recent past.

The traditional landscape, urban or rural or wilderness, was in large measure a two-dimensional space composed of well-defined surfaces—green fields, dark roads, sparkling water, the exteriors of houses and woods. Those surfaces were where we worked and moved and related to others. To be indoors was to lose our social identity. We belonged in the visible two-dimensional world; what lay underneath was the dark home of invisible forces. An old English law forbade the peasant from digging more than nine inches deep lest he endanger the permanent spatial order, and much environmental action is still concerned with preserving the beauty and health of the surface landscape.

But without our being aware of it, we are redefining the landscape and our perception of the world by emphasizing the vertical— the dimension of *depth*. The West, significantly enough, is increasingly dependent not on agriculture and grazing—the exploitation

of the horizontal surface—but on the vertical exploitation, by means of oil wells, coal mines, gas fields, and the search for underground water. We dig and drill and blast in quest of energy and wealth. We excavate to learn about the past. The farmhouse stands in apparent isolation, but three feet down, pipes and lines and cables link it to the community. It cannot be pure coincidence that we ourselves are turning inward to explore our hidden life. Depth psychology and deep ecology are for many the way to know reality.

However we explain this new orientation toward the vertical, toward the interior, this search for origins and for truth in another dimension, we need not interpret this kind of profundity with any great enlightenment or wisdom. It has its shortcomings-not only psychologically but in terms of the landscape: the sense of community no longer implies an exchange of services but a vague, fluctuating, spiritual affinity; a sharing of cults and causes and addictions; and an indifference to the visual consequences of inner-directed concern. Spatial distinctions, often the source of efficiency and beauty, are seen as temporary and superficial; what we look for increasingly in the landscape is a kind of emotional kick, a direct visceral reaction that entirely bypasses any social verdict or any sense of participation. Death Valley, the nuclear landscapes of Nevada, and the local landfill provide the same thrill.

Yet, we also look for a deeper understanding of nature and of ourselves, and it is much too early to know the ultimate religious consequences of this approach. "Terra incognita" is an appropriate term for this third, still-evolving landscape, and any attempt to give it symbolic form, to reveal its aesthetic potential, is to be welcomed as a valuable source of enlightenment.

John B. Jackson is a landscape historian. He has taught at Harvard and Berkeley, and has published numerous books, including The Necessity of Ruins.

Biography

Charles Fahlen

Born 1939, San Francisco, California.
B.A., California State University, San Francisco, 1962.
M.F.A., Otis Art Institute, Los Angeles, 1965.
Slade School, University of London, 1967.
Professor, Moore College of Art and Design, Philadelphia, 1967-present.

Grants and Awards

1965 Elsie De Wolf Traveling Fellowship
1967 Fulbright-Hayes Grant
1980 National Endowment for the Arts, Individual Grant
1982 Pennsylvania Council on the Arts, Individual Grant
 Moore College of Art Grant
1984 Moore College of Art Grant
1985 Hazlett Memorial Award for Excellence in the Arts
 Pennsylvania Council on the Arts, Individual Grant
1986 Moore College of Art Grant
1988 National Endowment for the Arts, Individual Grant
1991 Pennsylvania Council on the Arts, Individual Grant

Selected Projects

1976 Untitled, Artpark, New York.
1977 Untitled, commission for Jack and Annette Friedland, Gladwyne, Pennsylvania.
 Untitled, commission for Morton Project, Philadelphia.
1978 *General Grant*, commission for Mr. and Mrs. D. W. Dietrich II, Chester Springs, Pennsylvania.
1980 *Oppenheimer Memorial*, unexecuted commission for Robert Oppenheimer Memorial Committee, Los Alamos, New Mexico.
 Site Works, commission for temporary work for Swarthmore College, Swarthmore, Pennsylvania.
1982 *Major*, commission for Berger Associates for Postal Workers' House, Philadelphia.
 Sculpture/300, commission for temporary work for Philadelphia Art Alliance. (Catalogue)
 Franklintown Park, proposal with George Patton, landscape architect, for Franklintown, Pennsylvania.
 Rovers, temporary work, Dag Hammarskjold Plaza, New York City.
1983 Untitled, commission for South Philadelphia Older Adults Center.

Untitled, proposal at request of Ewing Cole Cherry Parsky, architects, for Environmental Protection Agency building courtyard, Trenton, New Jersey.
1985 *Insites*, commission in collaboration with artists Marie Gee and Lynn Denton for temporary work for City of Philadelphia, Municipal Services Building Plaza. (Catalogue)
1986 *Philadelphia Vietnam Veterans Memorial*, proposal for commission in collaboration with architect Tom Applequist for Philadelphia Vietnam Veterans Memorial Fund.
1987 *For Potter's Field*, commission with poet Steven Berg for temporary work for Collaborations, Inc. ("We the People-200"), Washington Square, Philadelphia. (Catalogue)
 Kerouac Commemorative, proposal for commission with Brown and Rowe, landscape architects, for City of Lowell, Historic Preservation Commission, Lowell, Massachusetts.
1988 *Diamond Park*, awarded commission, Philadelphia Redevelopment Authority.
 Tidal Park, commission in collaboration with artist Doug Hollis for City of Port Townsend, Washington.
1990 *Devil's Tower*, multiple object in edition of 150, Institute of Contemporary Art, University of Pennsylvania, Philadelphia.
1991 *Colter's Hell*, temporary work in conjunction with "Charles Fahlen," Institute of Contemporary Art, University of Pennsylvania, Philadelphia.

Selected Individual Exhibitions

1971 Richard Feigen Gallery, New York City.
1973 Pennsylvania Academy of the Fine Arts, Philadelphia.
1974 Henri 2, Washington, D.C.
1975 Stefanotti Gallery, New York City.
1976 Marian Locks Gallery, Philadelphia. (Catalogue)
 J. H. Duffy & Sons, New York City. (Catalogue)
1977 Marian Locks Gallery, Philadelphia.
1978 Droll/Kolbert Gallery, New York City.
1979 Marianne Deson Gallery, Chicago.
1980 Marian Locks Gallery, Philadelphia.
1981 Frank Kolbert Gallery, New York City.
1982 Marian Locks Gallery, Philadelphia.
1984 Marian Locks Gallery, Philadelphia.
1985 Hazlett Memorial Awards Exhibition. Traveled in Pennsylvania to Southern Alleghenies Museum of Art, Loretto; University Art Gallery, University of Pittsburgh; Philadelphia Art Alliance.
1987 Lawrence Oliver Gallery, Philadelphia. (Brochure essay)

1989 Lawrence Oliver Gallery, Philadelphia. (Brochure essay)
1991 "Charles Fahlen, Institute of Contemporary Art, University of Pennsylvania, Philadelphia. (Catalogue)

Selected Group Exhibitions

1972 "Grids," Institute of Contemporary Art, University of Pennsylvania, Philadelphia. (Catalogue)
1973 "Biennial of Contemporary American Painting and Sculpture,"
Whitney Museum of American Art, New York City. (Catalogue)
1974 "Seventy-first American Exhibition," Art Institute of Chicago. (Catalogue)
"Made in Philadelphia," Institute of Contemporary Art, University of Pennsylvania, Philadelphia. (Catalogue)
1975 "Summer Exhibition: Outdoor Sculpture," Merriewold West Gallery, Far Hills, New Jersey. (Catalogue)
1976 "Philadelphia: Three Centuries of American Art," Philadelphia Museum of Art. (Catalogue)
"Philadelphia/Houston Exchange," Institute of Contemporary Art, University of Pennsylvania, Philadelphia. (Catalogue)
1977 "Spectrum—'77," Charlotte Crosby Kemper Gallery, Kansas City Art Institute, Missouri.
1978 "Indoor/Outdoor Sculpture," Institute of Art and Urban Resources, P.S. 1, Long Island City, New York.
"Contemporary Drawings: Philadelphia," Pennsylvania Academy of the Fine Arts, Philadelphia, and Philadelphia Museum of Art. (Catalogue)
1979 "American Sculpture 1970-1980," Perkins Center for the Arts, Moorestown, New Jersey.
"Eight Sculptors," Albright Knox Art Gallery, Buffalo, New York. (Catalogue)
"Contemporary Pennsylvania Sculpture Inaugural Exhibition," William Penn Memorial Museum and Archives, Harrisburg, Pennsylvania.
"Masks, Tents, Vessels, and Talismans," Institute of Contemporary Art, University of Pennsylvania, Philadelphia. (Catalogue)
"Contemporary Sculpture: Selection from the Collection of the Museum of Modern Art," Museum of Modern Art, New York City. (Catalogue)

1980 "Material Pleasures: The Fabric Workshop," Museum of Contemporary Art, Chicago. (Catalogue)
1981 "Possibly Overlooked Publications," Landfall Gallery, Chicago. (Catalogue)
1982 "Art Materialized: Selections from The Fabric Workshop," New Gallery of Contemporary Art, New York City. Traveled to Carson Shapiro Gallery, Denver. (Catalogue)
1983 "Horses," Robert Freidus Gallery, New York City.
"Sculptors Who Teach," Governor's Garden (Governor's Mansion), Harrisburg, Pennsylvania.
"Works on Paper," Matthew Hamilton Gallery, Philadelphia.
1984 "Naturlich," Matthew Hamilton Gallery, Philadelphia.
"A Growing American Treasure: Recent Acquisitions and Highlights from the Permanent Collection," Pennsylvania Academy of the Fine Arts, Philadelphia. (Catalogue)
"Selected Recent Acquisitions," Weatherspoon Art Gallery, University of North Carolina, Greensboro. (Catalogue)
"Art on Paper 1984," Weatherspoon Art Gallery, University of North Carolina, Greensboro.
1985 "Small Monuments," Tyler Gallery, Temple University Center City, Philadelphia.
"The Return of the Figure," Southern Alleghenies Museum of Art, Saint Francis College Mall, Loretto, Pennsylvania
"The Challenge of Collaboration," Cleveland Center for the Arts. (Catalogue)
1986 "Perspectives from Pennsylvania," Carnegie-Mellon University Art Gallery, Pittsburgh, Pennsylvania. (Catalogue)
"Philadelphia Collects: European and American Art since 1940," Philadelphia Museum of Art. (Catalogue)
"Sculpture from the Permanent Collection of the Pennsylvania Academy of the Fine Arts," Pennsylvania Academy of the Fine Arts, Philadelphia. (Catalogue)
"Perspectives on the '60s and '70s: Selections from the Permanent Collection," Neuberger Museum, State University of New York, Purchase.
"An Exhibition of Sculpture Proposals for the Port Townsend Waterfront Area, by Charles Fahlen and Doug Hollis, Joan Brown and Charles Greening, Lloyd Hamrol and Buster Simpson, and Mary Miss," The Public Art Space, Seattle.

1987 "New Attitudes: Recent Pennsylvania Abstraction," Southern Alleghenies Museum of Art, Loretto, Pennsylvania. (Catalogue)
1988 "Summer Group Exhibition," Lawrence Oliver Gallery, Philadelphia.
1989 "Martha Diamond, Charles Fahlen, Lois Lane," Tavelli Gallery, Aspen, Colorado.
1990 "Contemporary Philadelphia Artists: A Juried Exhibition," Philadelphia Museum of Art. (Catalogue)
1991 "Artists Choose Artists," Institute of Contemporary Art, University of Pennsylvania, Philadelphia. (Catalogue)
"Visions/Revisions: Selections from the Contemporary Collection," Denver Art Museum, Colorado.
"The Next Show," Gallery at the State Theater Center for the Arts, Easton, Pennsylvania.

Selected Collections

AT&T, Basking Ridge, New Jersey
Dechert, Price & Rhoads, Philadelphia
Denver Art Museum, Colorado
Frances and Sidney Lewis, Richmond, Virginia
Museum of Modern Art, New York City
Neuberger Museum, State University of New York, Purchase
New Jersey State Museum, Trenton
The Noyes Museum, Oceanville, New Jersey
The Oakland Museum, Oakland, California
Pennsylvania Academy of the Fine Arts, Philadelphia
Philadelphia Museum of Art
Prudential Life Insurance, Philadelphia
Artco Ltd. Towers, Perrin, Forester, & Crosby
Weatherspoon Art Gallery, University of North Carolina, Greensboro

Selected Bibliography

Allison, Michael J. *New Attitudes: Recent Pennsylvania Abstraction* [Catalogue]. Loretto, Pennsylvania: Southern Alleghenies Museum of Art, 1987.

Ashton, Dore. "Beyond Literalism, but Not beyond the Pale." *Arts Magazine* (November 1968).

Battcock, Gregory. "Da New York Notizie—Assailing Technology." Domus (September 1975).

_____, Michael Findley, and Marian Locks. *Charles Fahlen* [Catalogue]. New York City/Philadelphia: J. H. Duffy & Sons and Marian Locks, 1976.

Baur, John I. H. *1973 Biennial Exhibition of Contemporary Art* [Catalogue]. New York City: Whitney Museum of American Art, 1973.

Berger, David. "Public Art: Port Townsend Process Dramatizes Fair Market Value." *Seattle Times/Seattle Post Intelligencer* (1984).

Betz, Margaret. "New York Reviews." *Artnews* (September 1976).

Boasberg, Leonardo. "Sculpture Will Be Wrought by a Trio". *The Philadelphia Inquirer* (February 1985).

Bourdon, David. "Art." *The Village Voice* (31 March 1975).

Brukmann, Korte. "Wave Gallery Chosen as Waterfront Memorial." *The Daily News* [Port Townsend, Washington] (December 1984).

Cavaliere, Barbara. Review. *Arts Magazine* (November 1978).

Cogan, Katherine. "In-Sites '85." *Art Matters* (June 1985).

_____, and Ann Jarmusch. "Another Philadelphia First." *Philadelphia Daily Muse* [special to Philadelphia Daily News] (June 1985).

d'Addario, M. A. "Charles Fahlen." *New Art Examiner* (March 1980).

Delahanty, Suzanne. *Made in Philadelphia* [Catalogue]. Philadelphia: Institute of Contemporary Art, University of Pennsylvania, 1974.

_____. *The Philadelphia/Houston Exchange* [Catalogue]. Philadelphia: Institute of Contemporary Art, University of Pennsylvania, 1976.

deWit, Margot, and Marsha Moss. *S/300 Sculpture Tricentennial* [Catalogue]. Philadelphia: Philadelphia Art Alliance, 1982.

Donohoe, Victoria. "Grappling with Charles Fahlen." *The Philadelphia Inquirer* (April 1973).

_____. "Penn Loves These Unappreciated Artists." *The Philadelphia Inquirer* (10 November 1974).

_____. "Architecture/Arts." *The Philadelphia Inquirer* (10 October 1976).

_____. "With a Sense of Quiet Beauty and Mystery." *The Philadelphia Inquirer* (6 April 1980).

_____. Review. *The Philadelphia Inquirer* (April 1982).

_____. "Sculpture Evokes Landscape Forms." *The Philadelphia Inquirer* (14 April 1984).

Elderfield, John. "Grids." *Artforum* (May 1972).

England, Terry. "Questions Aired Over Abstract Memorial to Robert Oppenheimer." *The New Mexican* (18 December 1980).

Flood, Richard. "Material Pleasures: The Fabric Workshop at ICA." *Artforum* (October 1980).

Forgey, Benjamin. "Impressions of Five Exhibits." *Washington Star News* (19 February 1974). _____. "Washington, D.C. Roundup." *Artnews* (Summer 1974).

Forman, Nessa. "No Frills in Fahlen's Work." *The Philadelphia Bulletin* (22 April 1973).

Foster, Hal. Review. *Artforum* (May 1981).

Frank, Peter. "Philadelphia: Focus on the Contemporary." *Artnews* (November 1973).

_____. "New York Reviews." *Artnews* (October 1976).

_____. "Prepositional Spaces." *The Village Voice* (2 October 1978).

Gerrit, Henry. Review. *Artnews* (May 1981).

Glowen, Ron. "Port Townsend: Tidal Park Revives Old Port." *Public Art Review* (Winter-Spring 1989).

Goodyear, Frank H. *Contemporary Drawing: Philadelphia* [Catalogue]. Philadelphia: Pennsylvania Academy of the Fine Arts and Philadelphia Museum of Art, 1978.

Heinmann, Susan. "Reviews: Made in Philadelphia 2." *Artforum* (January 1975).

Huntington, Richard. "Albright Sculpture Exhibit a Treat." *Buffalo Currier Express* (1 April 1979).

Jacobs, Harold. *American Drawing 1968* [Catalogue]. Philadelphia: Moore College of Art, 1968.

Kardon, Janet. *Masks, Tents, Vessels, and Talismans* [Catalogue]. Philadelphia: Institute of Contemporary Art, University of Pennsylvania, 1979.

Katzive, David. *Artpark, The Program in Visual Arts* [Catalogue]. Lewiston, New York: Artpark, 1977.

Lippard, Lucy. *Grids* [Catalogue]. Philadelphia: Institute of Contemporary Art, University of Pennsylvania, 1972.

Marincola, Paula. *Independence Sites: Sculpture for Public Spaces* [Catalogue]. Philadelphia: Collaborations, Inc., 1987.

_____. *Chuck Fahlen* [Catalogue]. Philadelphia: Lawrence Oliver Gallery, 1989.

_____. "Philadelphia." *Contemporanea* (April 1990).

McClain, Matthew. Review. *New Art Examiner* (June 1982).

McFadden, Sarah. "Report from Philadelphia." *Art in America* (May-June 1979).

_____. Review. *Art in America* (June 1981).

McShine, Kynaston. *Contemporary Sculpture: Selections from the Collection of the Museum of Modern Art* [Catalogue]. New York City: Museum of Modern Art, 1979.

Percival, Sandra. "The Port Townsend Project." *Passages* [Seattle, Washington] (June 1986).

Perreault, John. *Beyond Literalism* [Catalogue]. Philadelphia: Moore College of Art, 1968.

_____. "Beyond Literalism." *Art International* (January 1969).

Quigley, Michael. *Material Pleasures: The Fabric Workshop at ICA* [Catalogue]. Philadelphia: Institute of Contemporary Art, University of Pennsylvania, 1979.

Reed, Susan. "Enigmatic Moments of Charles Fahlen." *South Street Star* (15 April 1982).

Rosenthal, Mark. *Philadelphia Collects Art since 1940* [Catalogue]. Philadelphia: Philadelphia Museum of Art, 1986.

Rubin, David S. "Chuck Fahlen at Lawrence Oliver." *Art in America* (December 1987).

Russell, John. "Gallery View." *The New York Times* (25 April 1976).

Sachs, Sid. "Site." *New Art Examiner* (March 1981).

Schultz, Douglas G. *Eight Sculptors* [Catalogue]. Buffalo, New York: Albright-Knox Art Gallery, 1979.

Schwartz, Joyce Pomeroy. *Artists and Architects, Challenges in Collaboration* [Catalogue]. Cleveland, Ohio: Cleveland Center for Contemporary Art, 1985.

Seidel, Miriam. "Chuck Fahlen." *New Art Examiner* (January 1990).

Shamash, Diane. "What Price Public Art? The One-Percent Solution." *Stroll* (December 1986-January 1987).

Shirey, David. "Downtown." *The New York Times* (30 January 1971).

Sollins, Susan. *Art Materialized: Selections from The Fabric Workshop* [Catalogue]. Philadelphia: Independent Curators, Inc., 1982.

Sozanski, Edward J. "Outdoor Exhibition Tries To Enliven a Concrete Plaza." *The Philadelphia Inquirer* (June 1985).

_____. "Five Artists Exhibit a Range of Moods in a Sculpture Series." *The Philadelphia Inquirer* (27 August 1987).

_____. Review. *The Philadelphia Inquirer* (1 October 1987).

Speyer, James. *Seventy-first American Exhibition* [Catalogue]. Chicago: Art Institute of Chicago, 1974.

Stewart, Patricia. "Philadelphia Artists at Moore." *The Drummer* (18 November 1975).

_____. Review. *The Philadelphia Arts Exchange* (January-February 1978).

_____. *Chuck Fahlen* [Catalogue]. Philadelphia: Lawrence Oliver Gallery, 1987.

Tamblyn, Christine. Review. *New Art Examiner* (June 1979).

Vanderlip, Diane. *PMA at MCA* [Catalogue]. Philadelphia: Moore College of Art, 1975.

_____. *Collection in Progress—200 or So Selections from the Collection of Milton Brutten and Helen Herrick* [Catalogue]. Philadelphia: Moore College of Art, 1977.

Zucker, Barbara. Review. *Artnews* (November 1978).